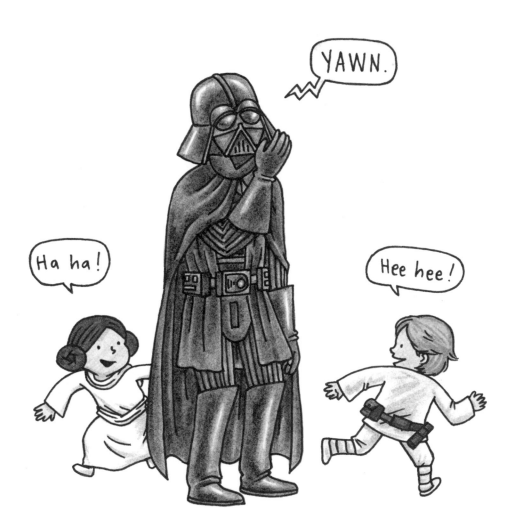

GOODNIGHT DARTH VADER ™

JEFFREY BROWN

CHRONICLE BOOKS
SAN FRANCISCO

LIBRARY OF CONGRESS CATALOGING-IN-PUBLICATION DATA:
BROWN, JEFFREY, 1975-
GOODNIGHT DARTH VADER / JEFFREY BROWN.
 P. CM.

 ISBN: 978-1-4521-2830-6
1. STAR WARS-COMIC BOOKS, STRIPS, ETC. 2. VADER, DARTH (FICTITIOUS
CHARACTER)-COMIC BOOKS, STRIPS, ETC. 3. BEDTIME- HUMOR
4. AMERICAN WIT AND HUMOR 5. GRAPHIC NOVELS. I. TITLE.
 PN6727. B75756 662014
 741.5'973--DC23
 2014031158

MANUFACTURED IN CHINA.
WRITTEN AND DRAWN BY JEFFREY BROWN.
DESIGNED BY MICHAEL MORRIS.

THANKS TO STEVE MOCKUS, J.W. RINZLER, MARC GERALD, MY FAMILY,
AND ALL OF MY READERS. SPECIAL THANKS TO RYAN GERMICK AND
MICHEAL LOPEZ AT GOOGLE FOR THE ORIGINAL INSPIRATION TO
MAKE DARTH VADER AND SON.

10 9 8 7 6 5 4 3 2

CHRONICLE BOOKS LLC
680 SECOND STREET
SAN FRANCISCO, CALIFORNIA 94107

WWW. CHRONICLEBOOKS.COM

WWW. STARWARS.COM

A long time ago in a galaxy far, far away.....

Episode Eight P.M. :
BEDTIME
Lord Darth Vader rules the Galaxy, while attempting to rule his twin children, Luke and Leia Skywalker. He has commanded them to go to bed, but they have other ideas.....

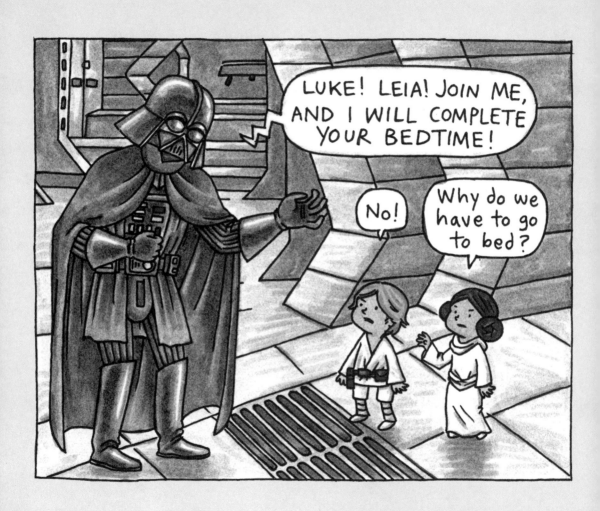

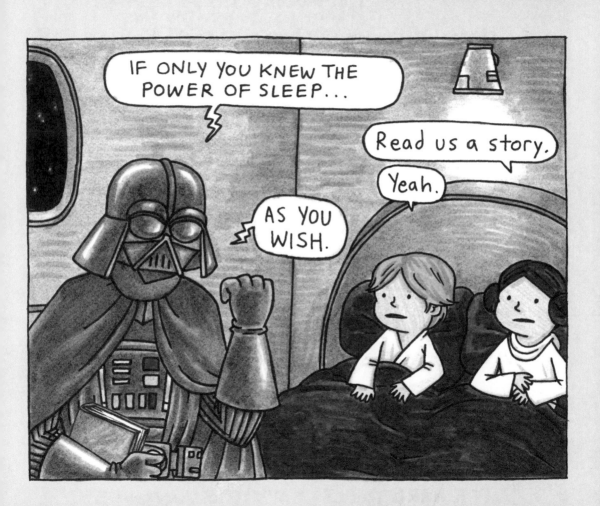

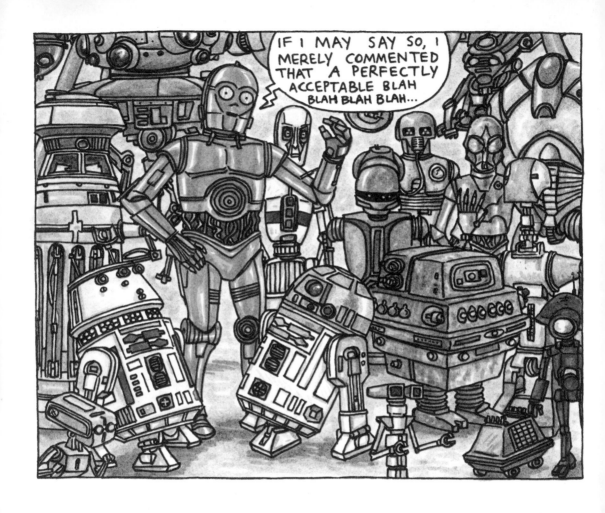

IT'S HARD TO SLEEP IF YOU'RE ANNOYED

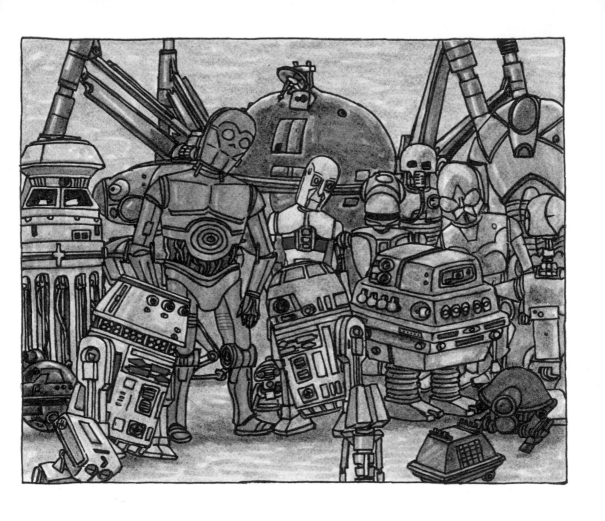

NOW IT'S TIME TO SHUT DOWN EACH DROID.

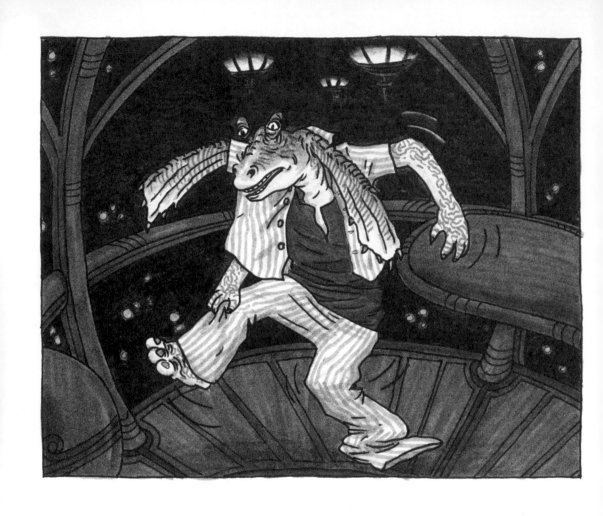

WHEN JAR JAR PUTS ON HIS PJS FOR BED

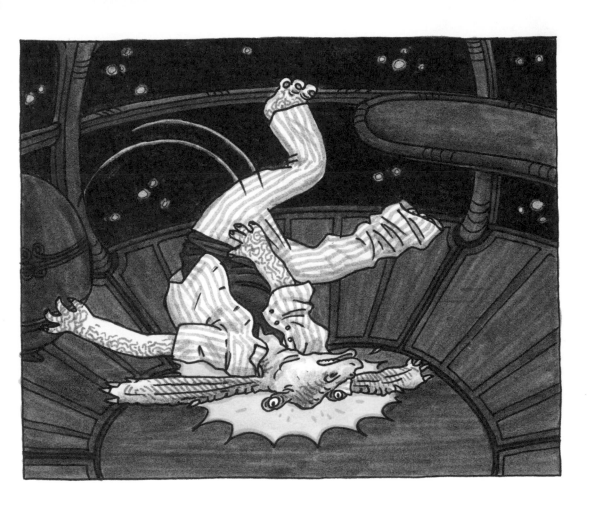

HE ALWAYS ENDS UP WITH A BONK ON THE HEAD.

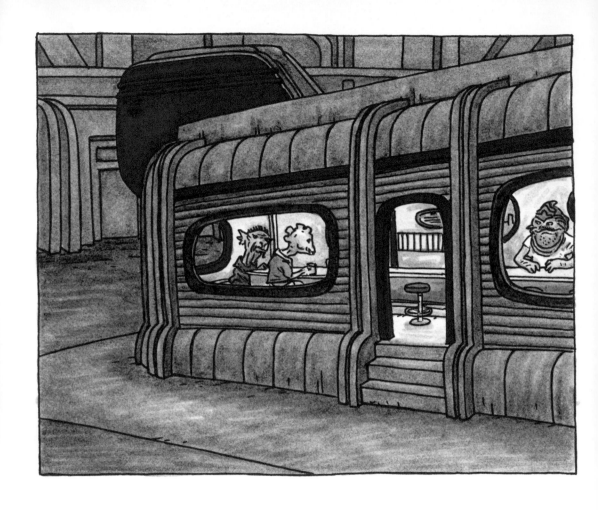

DEXTER'S DINER IS QUIET, WITH FEW PATRONS IN SIGHT

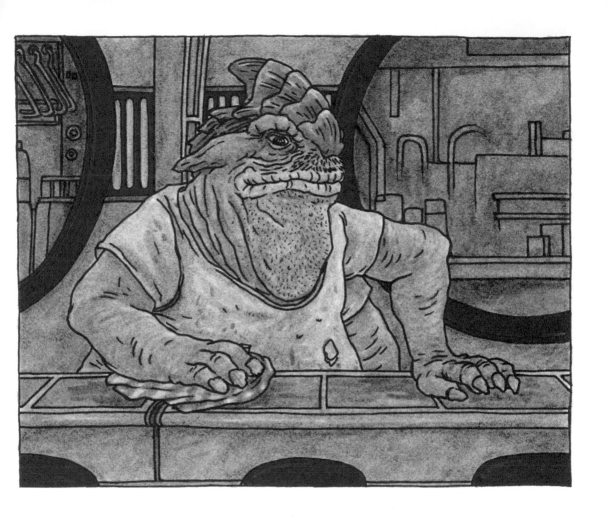

SOON IT'LL BE TIME TO TURN OFF THE LIGHT.

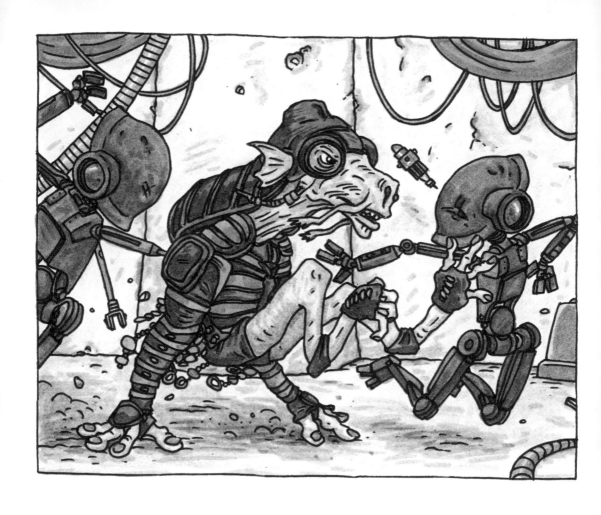

SEBULBA RACES TO ALWAYS BE BEST

EVEN WHEN HE GETS HIS BEAUTY REST.

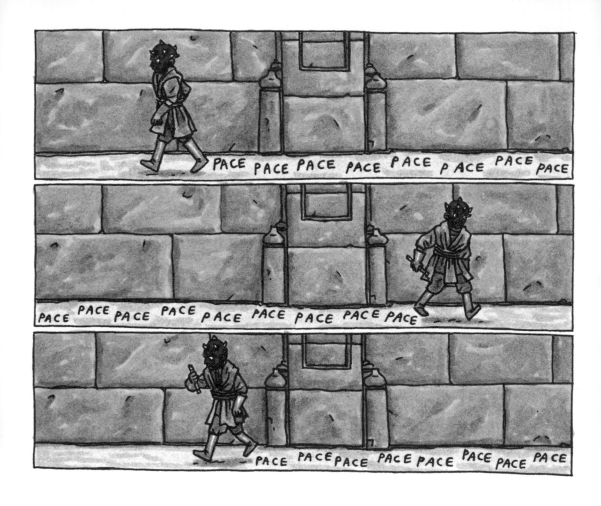

POOR DARTH MAUL IS PACING LONG INTO THE NIGHT

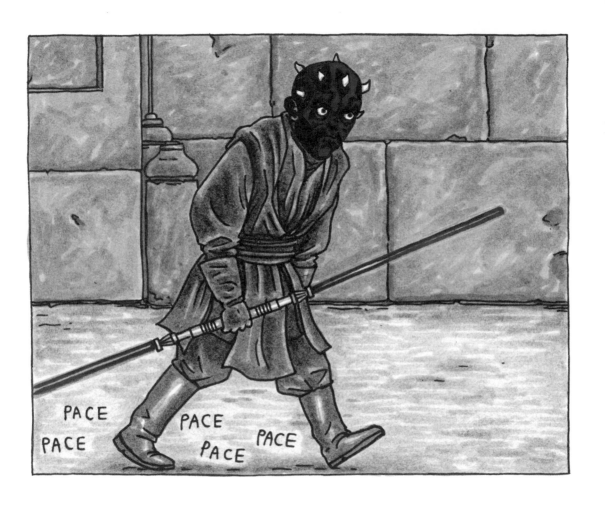

HE'S WIDE AWAKE AND CAN'T SLEEP, TRY AS HE MIGHT.

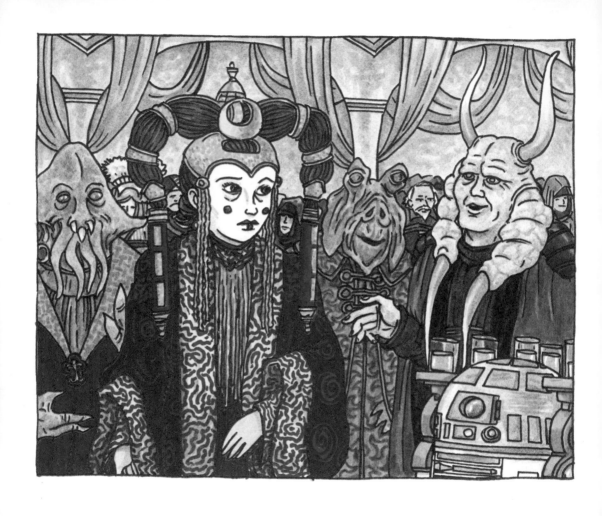

PADMÉ IS TIRED AFTER TOO MANY GALAS

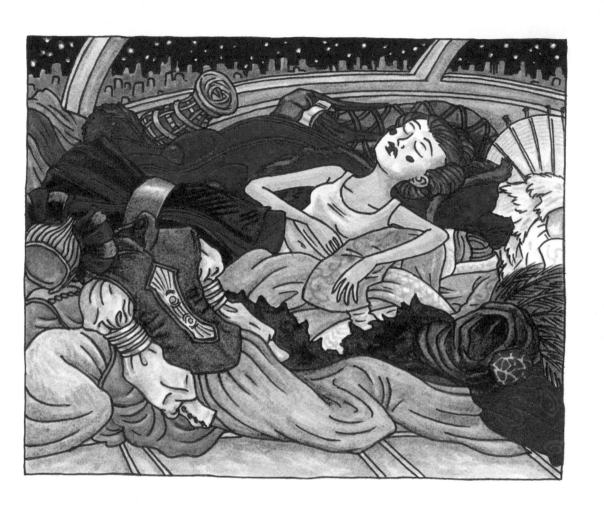

SO SLEEP IS QUITE WELCOME FOR QUEEN AMIDALA.

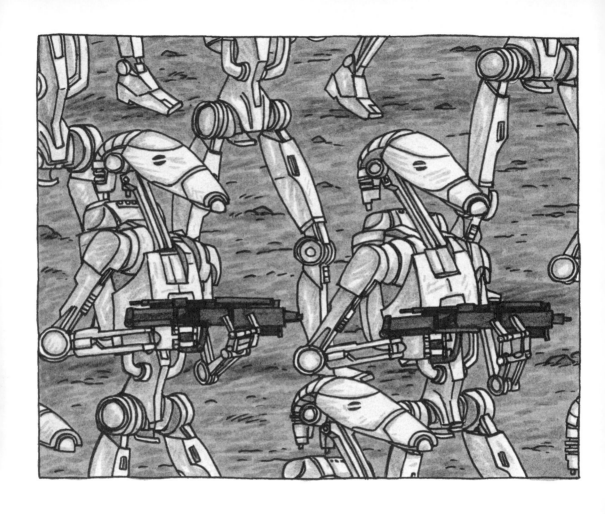

.IT TAKES A LONG TIME, IN FACT NOTHING TAKES LONGER

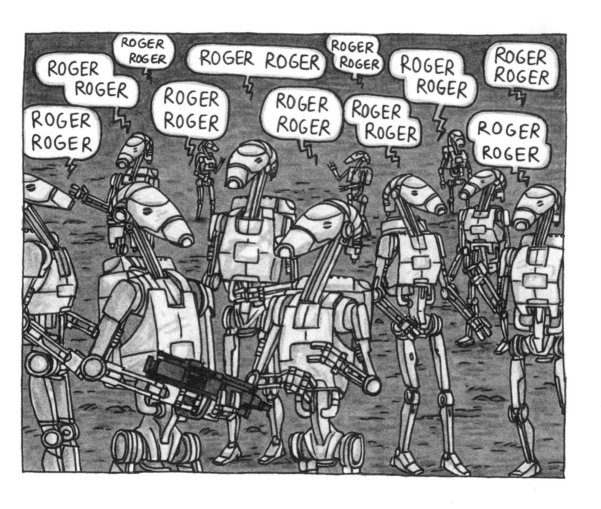

FOR BATTLE DROIDS TO SAY GOOD NIGHT TO EACH OTHER.

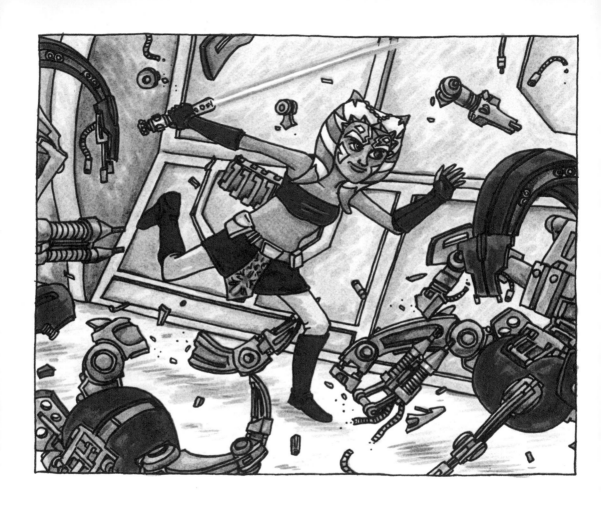

AHSOKA THE PADAWAN IS NOT READY FOR BED

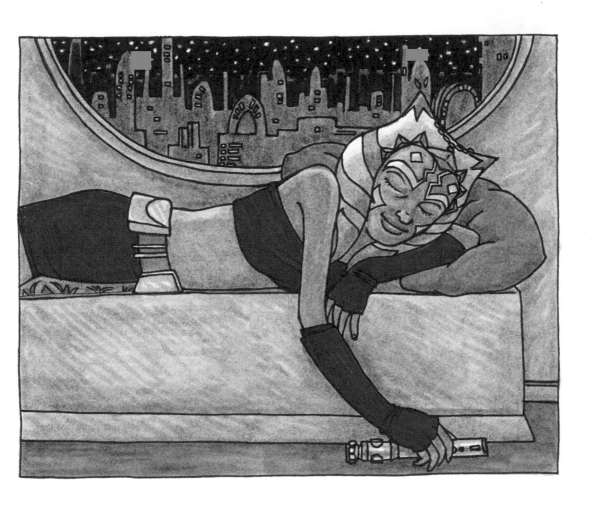

BUT SHE DRIFTS OFF TO SLEEP
WHEN SHE LAYS DOWN HER HEAD.

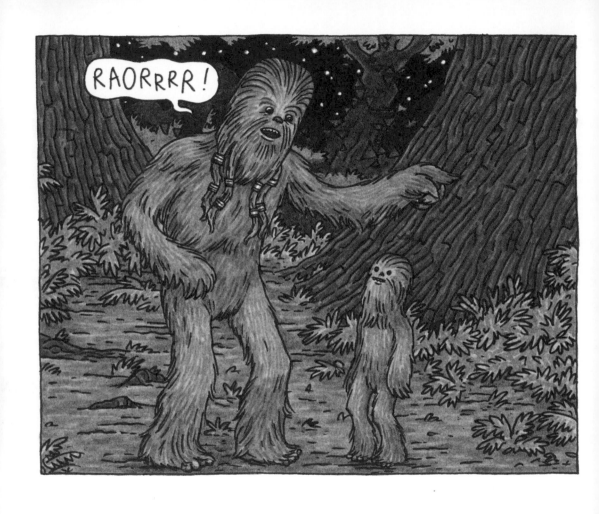

IT'S BEDTIME ON KASHYYYK FOR ALL THE WOOKIEES

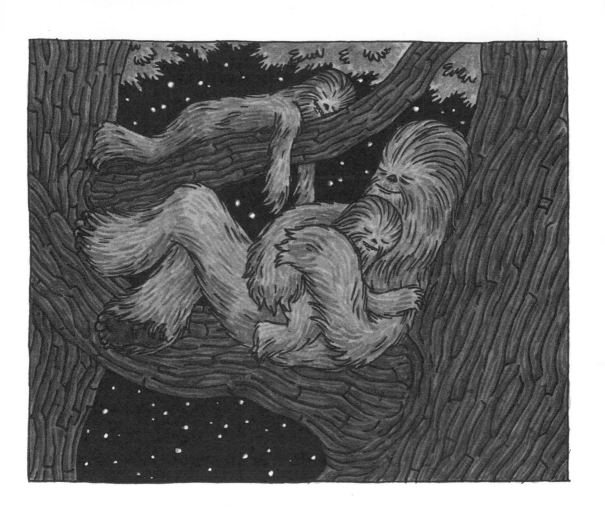

SO NOW THEY CLIMB HIGH TO SLEEP UP IN THE TREES.

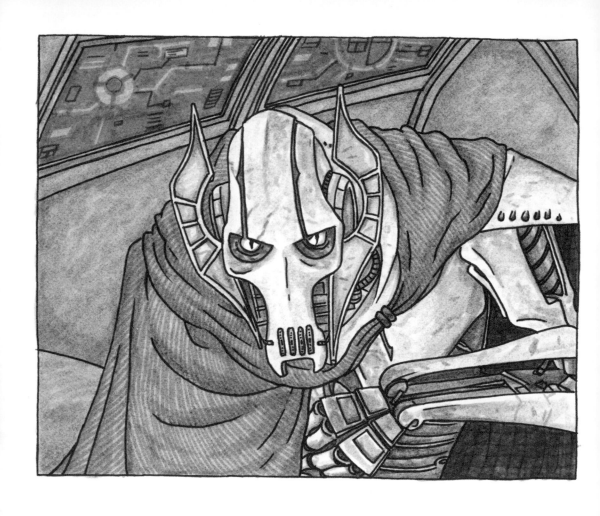

GETTING READY FOR BED, GENERAL GRIEVOUS IS DONE

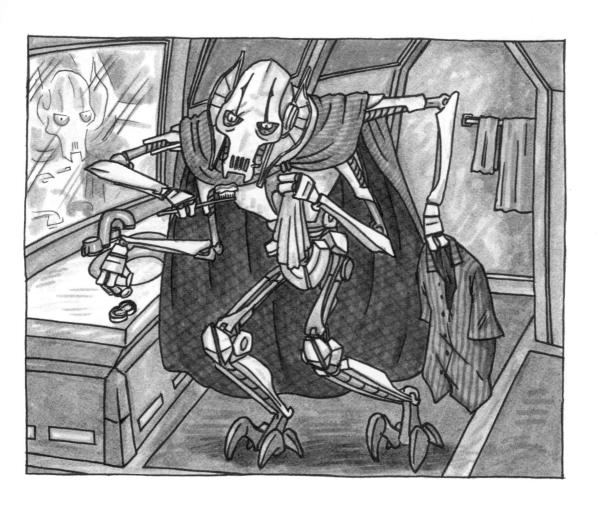

FOUR TIMES FASTER THAN ANYONE.

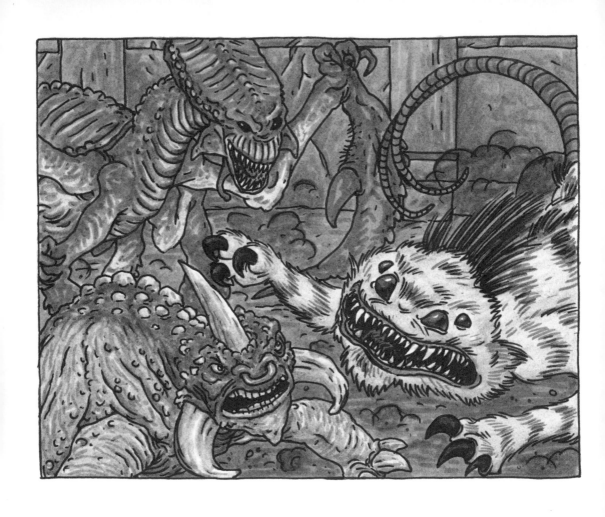

IN THE ARENA, IT'S ALWAYS A FIGHT

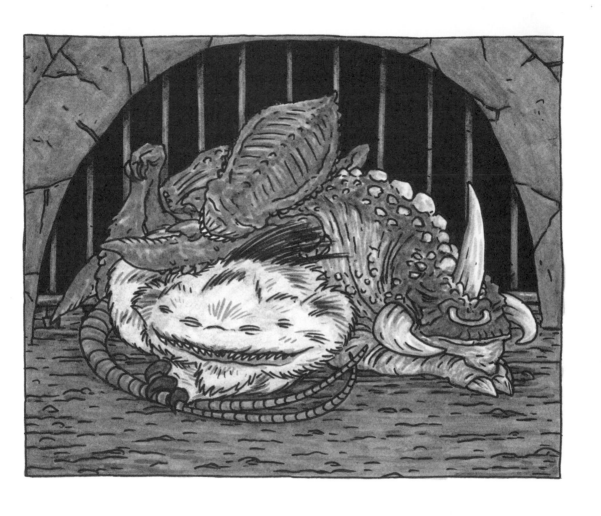

TO SETTLE THE CREATURES ALL DOWN FOR THE NIGHT.

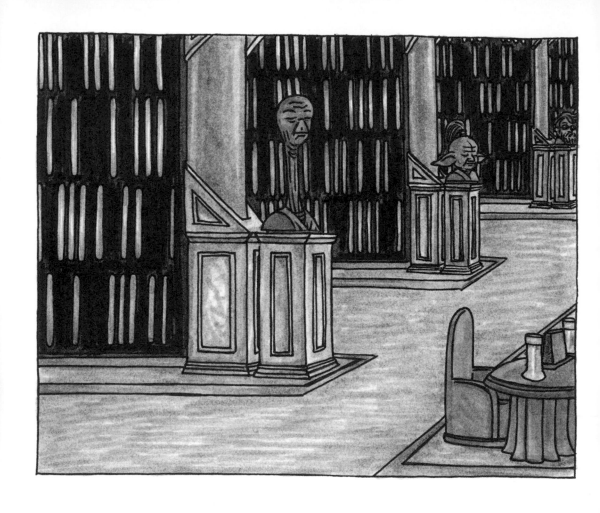

THE ARCHIVES ARE SILENT, THE JEDI ALL SLEEPING

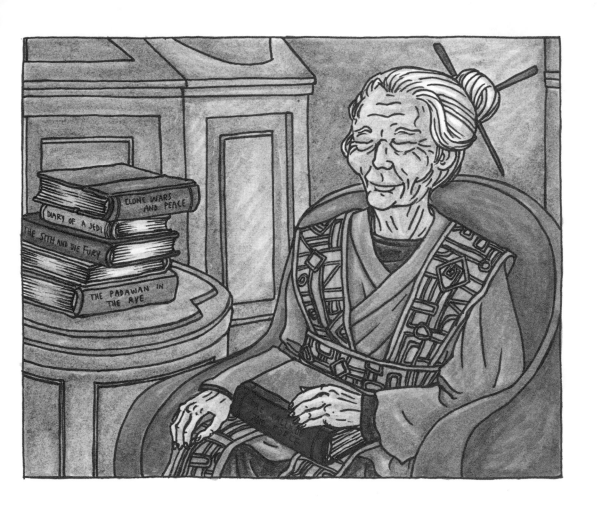

JOCASTA CAN NOW REST HER EYES AFTER READING.

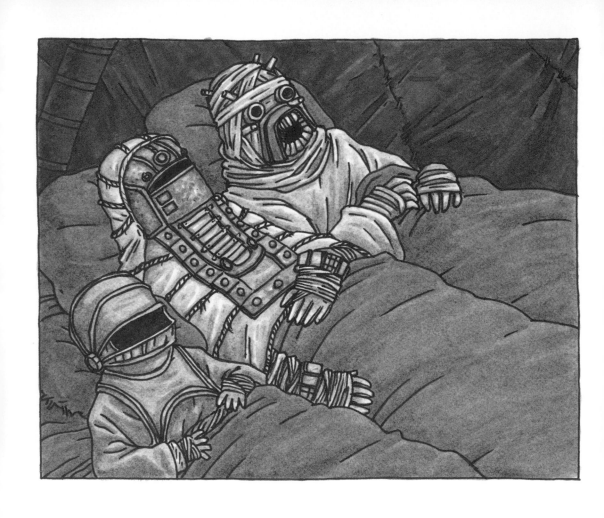

THE RAIDERS THEY SLEEP, THE DAY'S ROAMING A CHORE

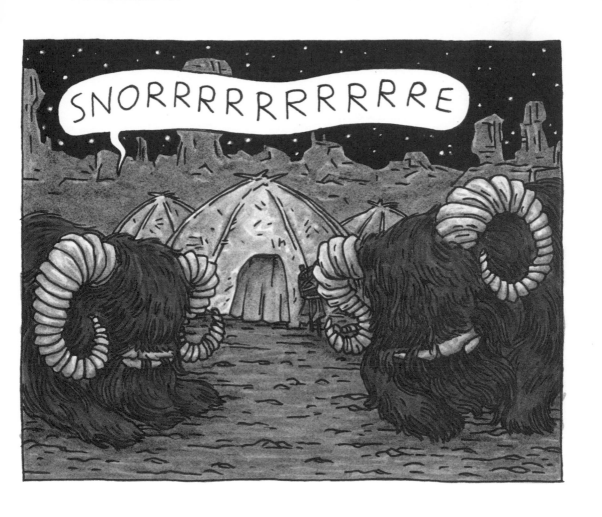

WHILE OUTSIDE THE BANTHAS CONTENTEDLY SNORE.

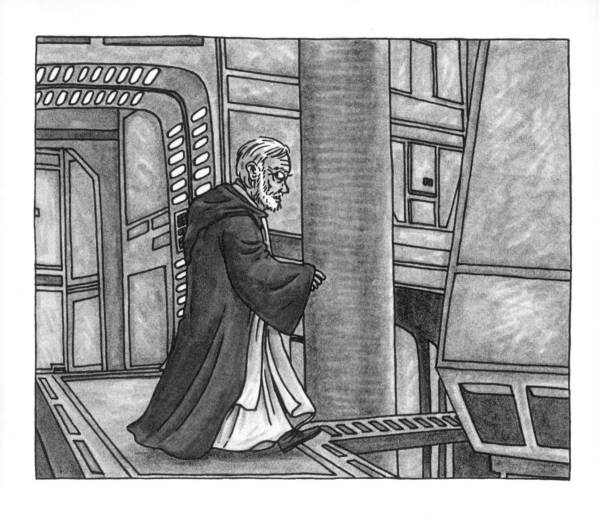

BEN GOES TO BED EARLY, HE IS VERY WISE

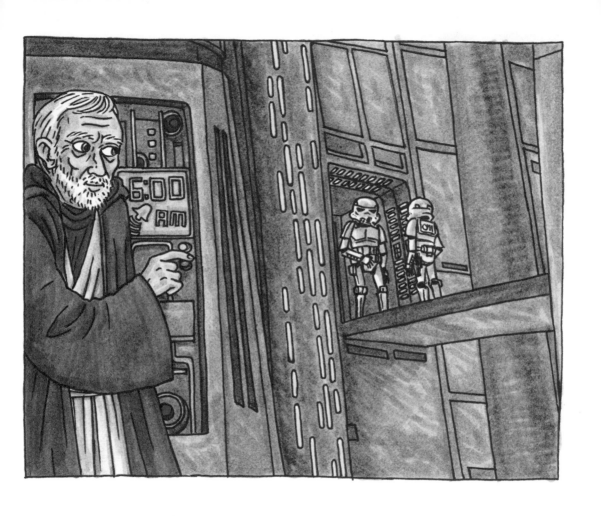

HE SETS HIS ALARM FOR A BRIGHT EARLY RISE.

THE JAWAS HAVE ALL GONE INSIDE FOR THE NIGHT

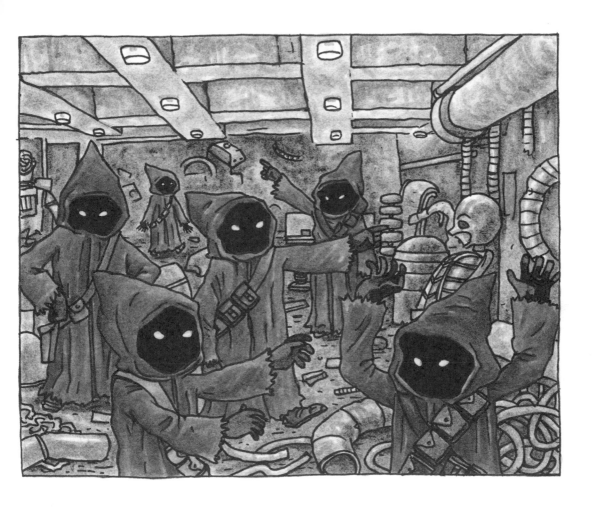

BUT NOW THEY WILL ARGUE
WHO SHOULD TURN OFF THE LIGHT.

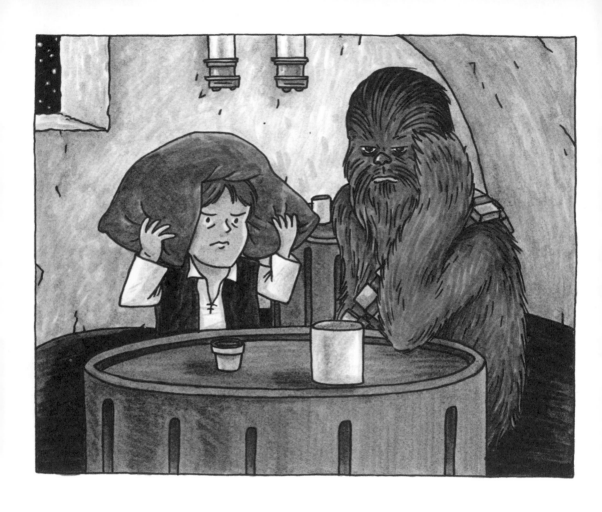

IT'S TOO HARD TO SLEEP FOR HAN SOLO AND CHEWIE

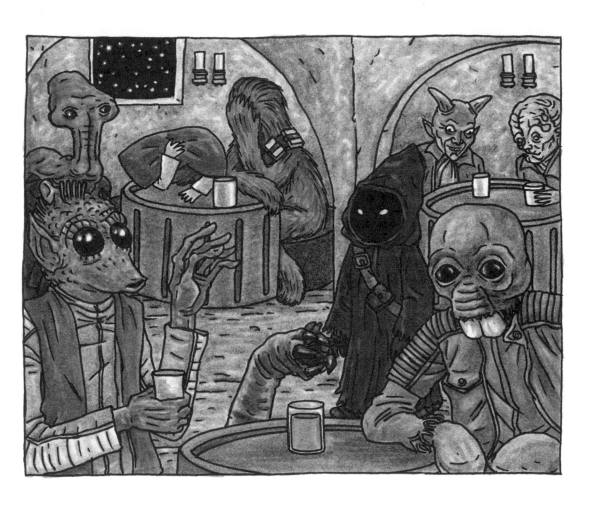

IN THIS WRETCHED HIVE OF SCUM AND VILLAINY.

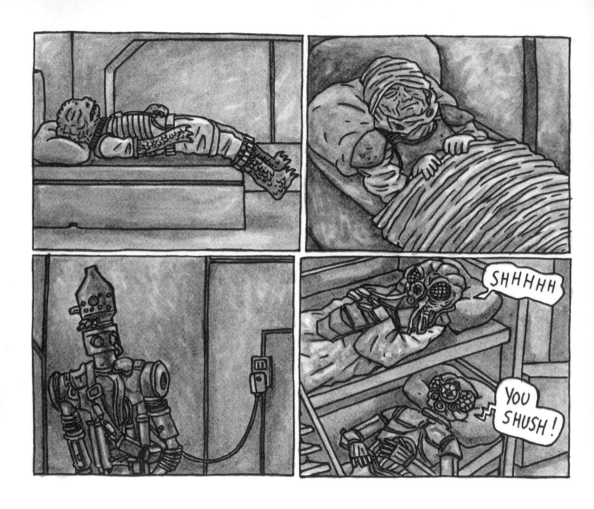

BOUNTY HUNTERS TUCK IN, ALL READY AND SET

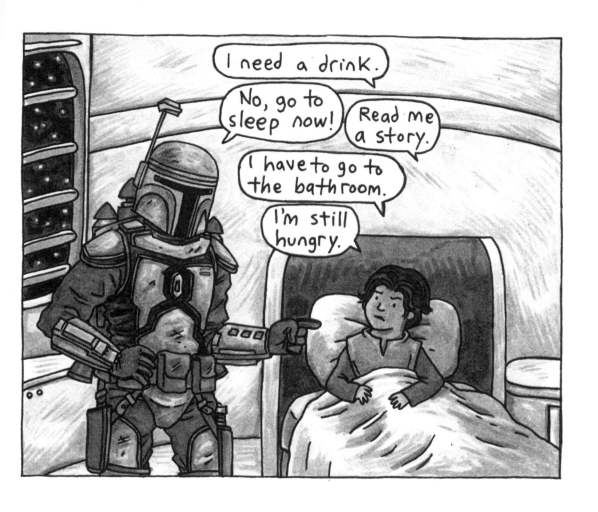

EXCEPT FOR YOUNG BOBA AND HIS DAD JANGO FETT.

IT'S EASY TO SLEEP ON THE CLOUD CITY GLEAMING

WHERE LANDO AND LOBOT LIE PEACEFULLY DREAMING.

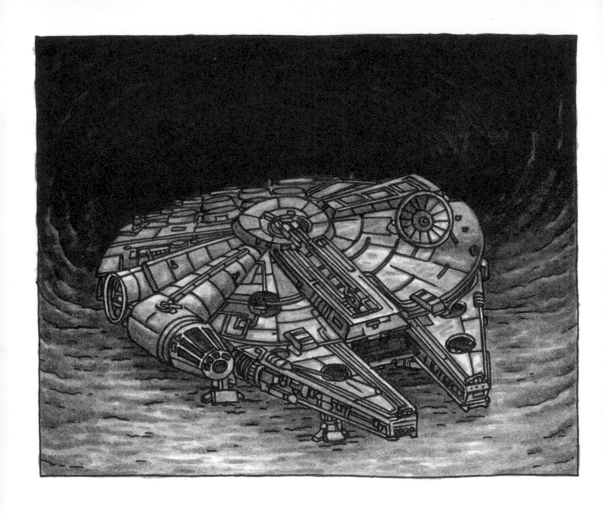

GOODNIGHT FALCON, SLEEP TIGHT

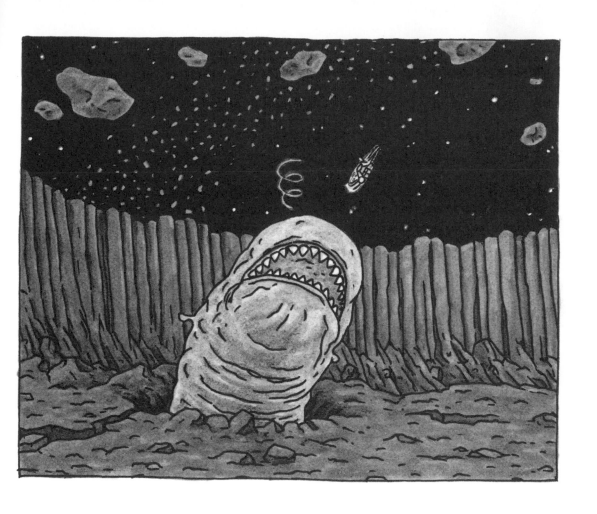

DON'T LET THE SPACE SLUG BITE.

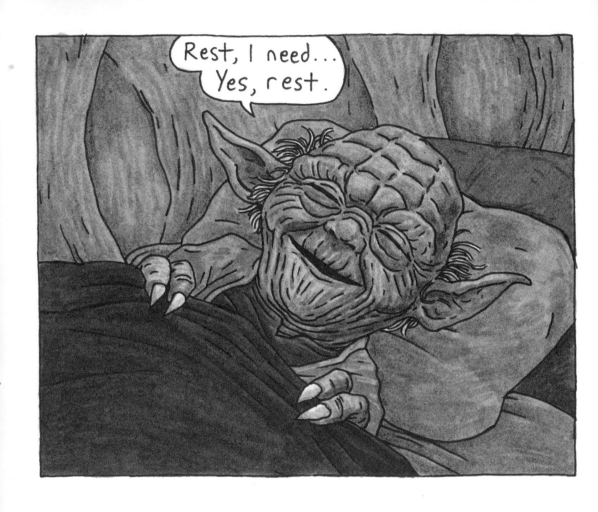

TIME FOR BED, IT IS FOR YODA

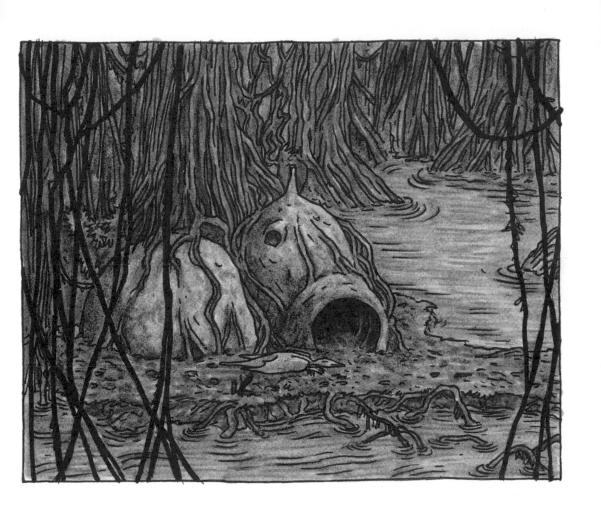

AND ALL OF SWAMPY DAGOBAH.

THE SUNS OF TATOOINE HAVE SET IN THE WEST

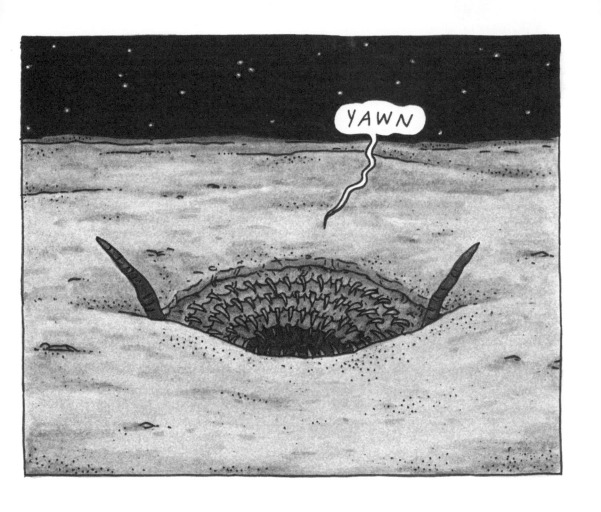

IT'S TIME FOR THE SARLACC TO SLEEP AND DIGEST.

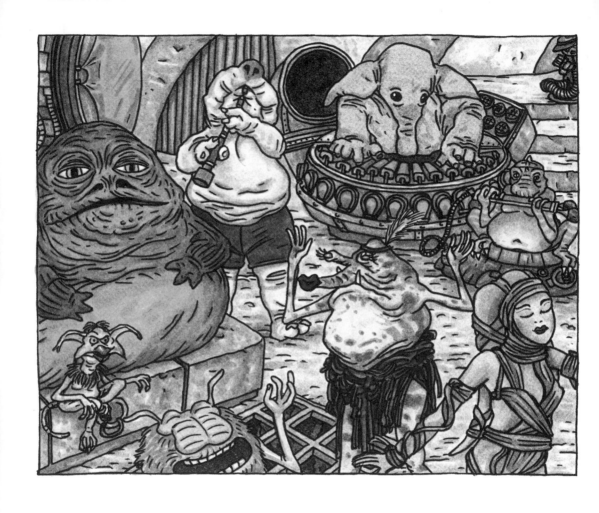

ALL THROUGH THE NIGHT, JABBA'S PLACE IS AROAR

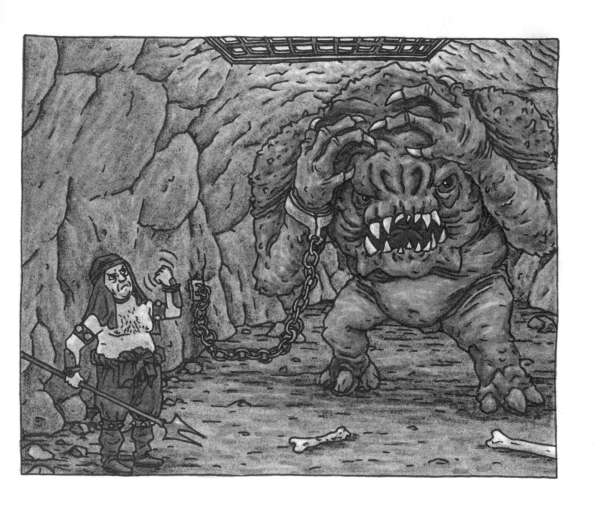

THE PARTY'S TOO LOUD FOR THE SLEEPY RANCOR.

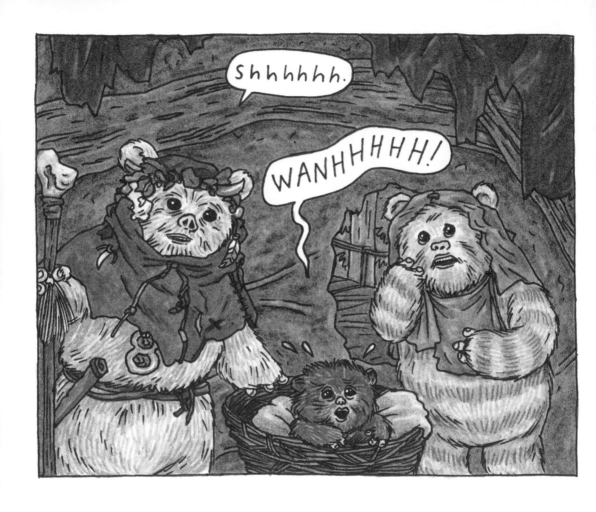

TOO NOISY OUTSIDE FOR BABY EWOKS?

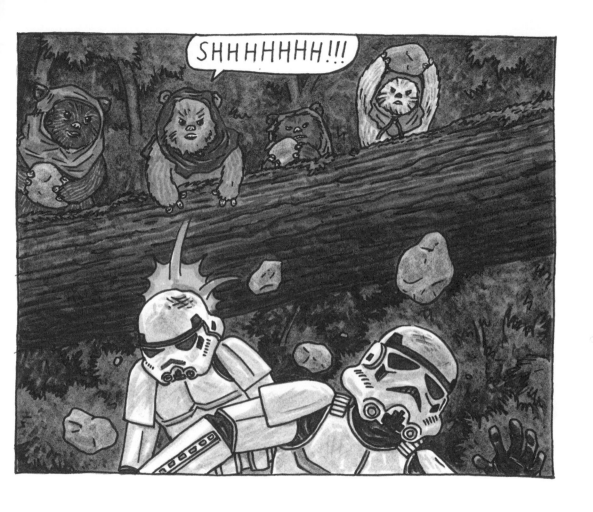

IT'S BEST WHEN THE EMPIRE'S BEEN SILENCED WITH ROCKS.

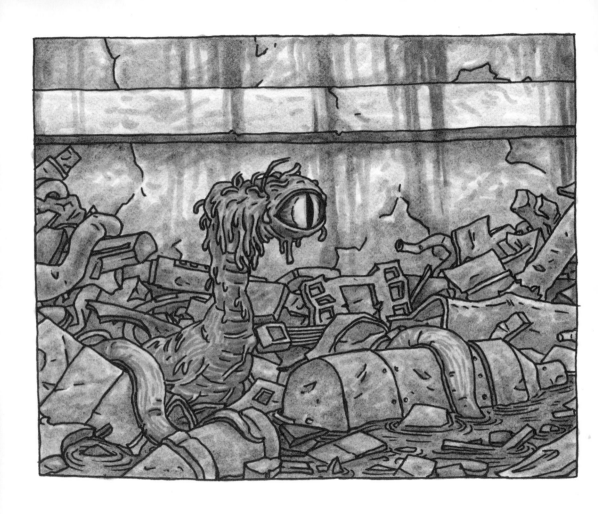

IT'S HARD TO BE COZY WHEN LIVING IN TRASH

BUT WHEN HE GETS TIRED, DIANOGA WILL CRASH.

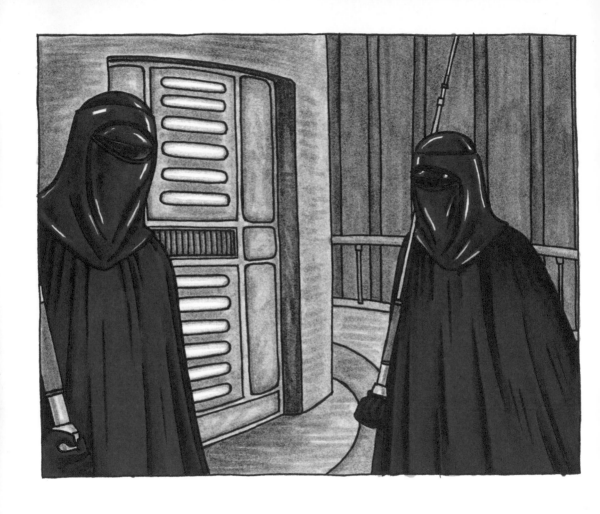

NEAR THE EMPEROR'S BEDROOM,
GUARDS HEAR NOISE FROM WITHIN

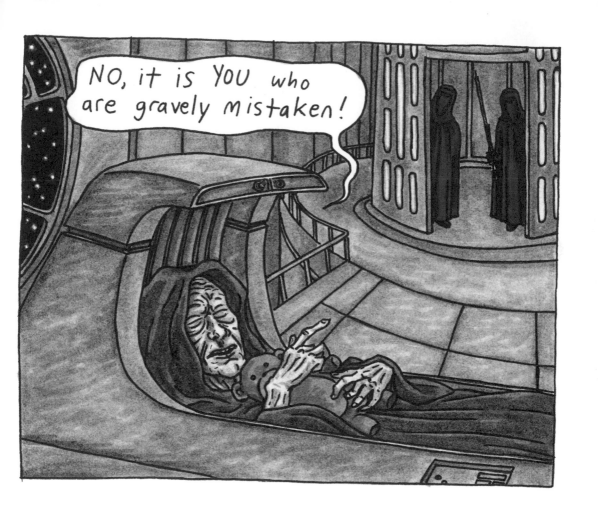

AS PALPATINE TALKS IN HIS SLEEP ONCE AGAIN.

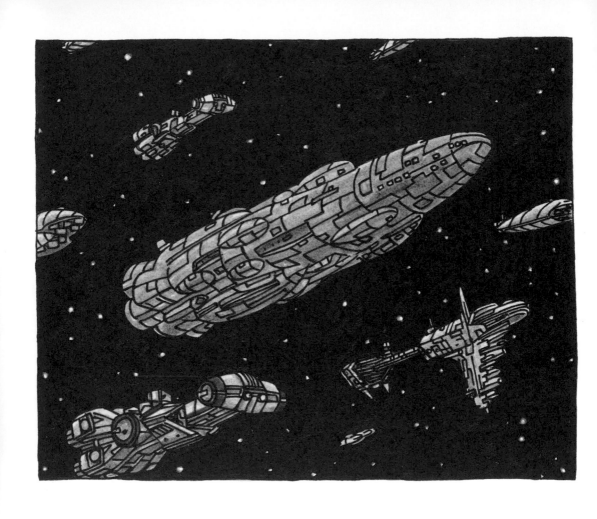

THE FLEET GOES TO BED, ASLEEP IN THE STARS

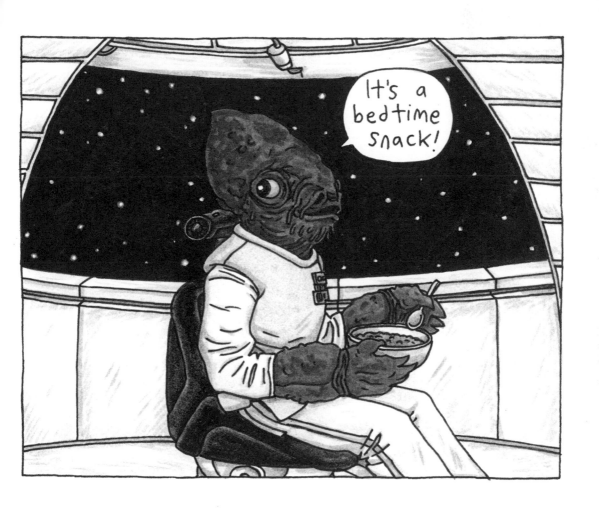

EXCEPT NOT JUST YET, FOR ONE HUNGRY ACKBAR.

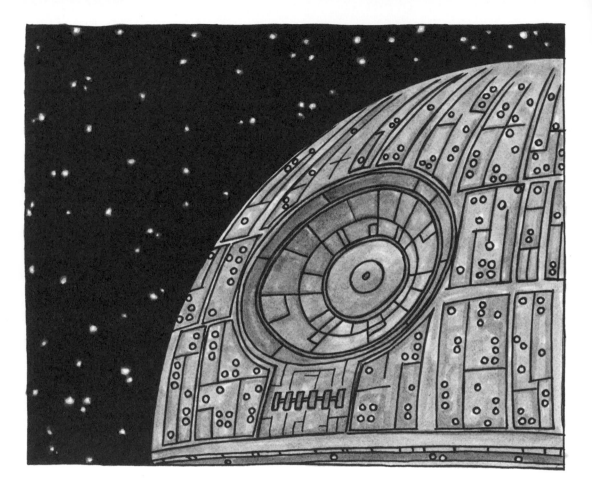

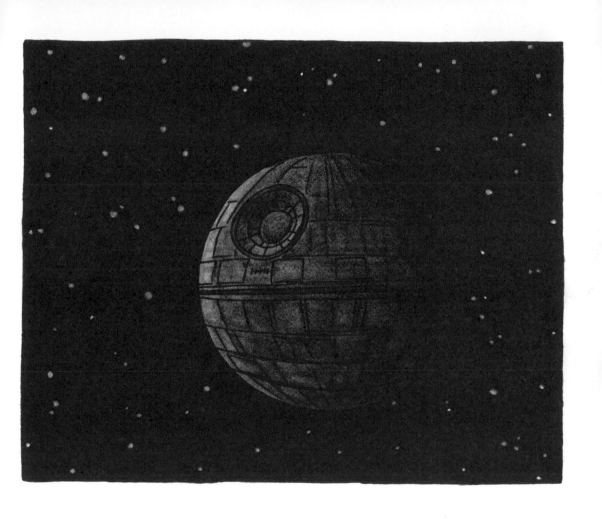

GOODNIGHT DEATH STAR.

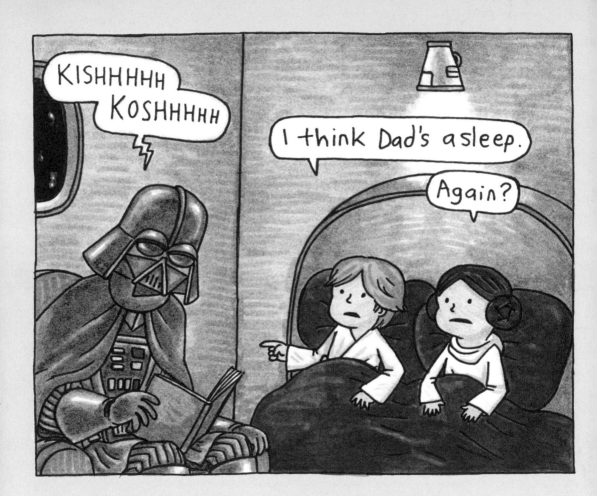

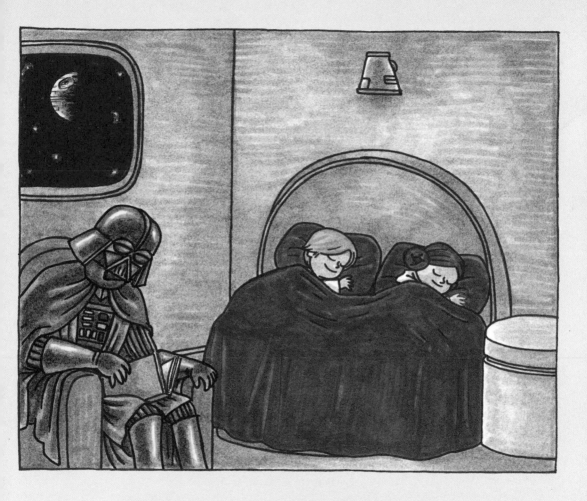

GOODNIGHT LUKE. GOODNIGHT LEIA.
GOODNIGHT DARTH VADER.

Jeffrey Brown is the author of numerous autobiographical comics, humorous graphic novels, and several bestselling Star Wars books. He lives in Chicago with his wife and two sons.

P.O. Box 120
Deerfield IL 60015-0120
USA

WWW. JEFFREYBROWNCOMICS.COM

ALSO BY JEFFREY BROWN
FROM CHRONICLE BOOKS:

Kids Are Weird
Vader's Little Princess
Darth Vader and Son
Cats Are Weird
Cat Getting Out Of A Bag

www.chroniclebooks.com